NATIONAL MUSEUM :: OF THE :: AMERICAN INDIAN

SMITHSONIAN INSTITUTION WASHINGTON, D.C.

MAP AND GUIDE

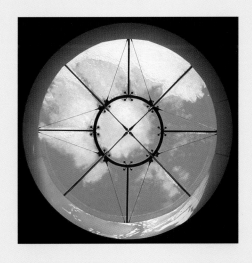

James Volkert

Linda R. Martin

Amy Pickworth

...la Publishers in association
...h the National Museum of the
...erican Indian, Washington, D.C.

D1114129

SCALA

NATIONAL
MUSEUM
∷ OF THE ∷
AMERICAN
INDIAN

SMITHSONIAN
INSTITUTION
WASHINGTON, D.C.

First published exclusively in 2004 for the
National Museum of the American Indian,
Smithsonian Institution, Washington, D.C.,
by Scala Publishers Ltd.
Northburgh House
10 Northburgh Street
London EC1A 0AT

Library of Congress Cataloging-in-
 Publication Data
Map and Guide: National Museum of the
 American Indian, Smithsonian Institution
p. cm.
ISBN 1 85759 330 8

Project Director and Head of Publications,
 NMAI: Terence Winch
Editor, NMAI: Amy Pickworth
Designer: Linda Males MCSD
Editorial and Production Director, Scala:
 Jessica Hodge
Architectural Consultant: Duane Blue Spruce
 (Laguna and San Juan Pueblo), NMAI
Photo Consultant: Tanya Thrasher (Cherokee),
 NMAI
Photo Coordinator: Leslie Cook, NMAI

Special thanks to Steve Bell, Cynthia
Frankenburg, Ann Kawasaki, Hayes Lavis,
Helen Scheirbeck, Colleen Schreier, Lou
Stancari, Holly Stewart, Thomas Sweeney
(Citizen Potawatomi), Leslie Wheelock
(Oneida), Randel Wilson

Printed and bound in China

The National Museum of the American Indian,
Smithsonian Institution, is dedicated to
working in collaboration with the indigenous
peoples of the Americas to foster and protect
Native cultures throughout the Western
Hemisphere. The museum's publishing
program seeks to augment awareness of Native
American beliefs and lifeways, and to educate
the public about the history and significance of
Native cultures.

CONTENTS

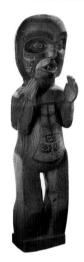

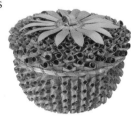

FOREWORD:
WELCOME TO A NATIVE PLACE

The breathtaking new National Museum of the American Indian opened on the National Mall on September 21, 2004. We are thus the new kid on the block—the 16th of the Smithsonian Institution's world-renowned museums. The Mall building encompasses 254,000 square feet. In our exhibition areas, you will see something in the neighborhood of 7,000 amazing works from scores of Native cultures, drawn from our monumental collection of more than 800,000 objects. We expect the museum to be a destination for millions of visitors every year.

Those are some of the key numbers you might find interesting about our new museum. But what do they all really add up to?

For however great the number of visitors to the museum, or however vast our collections, we feel that the significance of our presence on the National Mall and of our mission on behalf of Native peoples cannot be readily translated into hard numbers and linear sound bytes. At our heart, we feel we represent something intangible. We define a moment of reconciliation and recognition in American history, a time for Indian people to assume, finally, a prominent place of honor on the nation's front lawn. It is our most fervent hope that we will be an instrument of enlightenment, helping our visitors learn more about the extraordinary achievements of the indigenous people of the Western Hemisphere. We also hope that Native people will look upon the museum as a truly Native place, where they are welcome and honored guests.

This book will be, I trust, an illuminating and practical companion as you explore the wonders of our new Native place on the Mall. Through its pages, I hope you will be able to visit us often, even if from the distance of your own homes.

—W. Richard West, Jr. (Southern Cheyenne and member of the Cheyenne and Arapaho Tribes of Oklahoma), Founding Director, NMAI

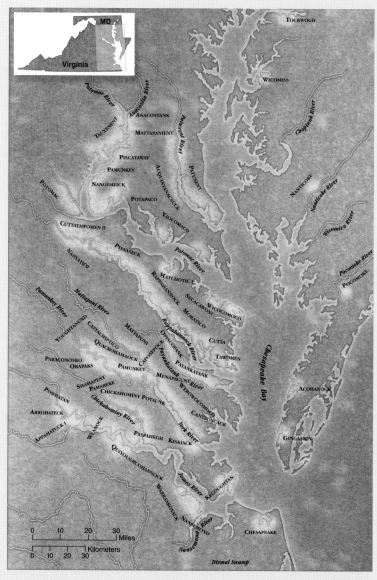

Native Communities in the Chesapeake Bay Area, ca. 1610

Many dozens of different tribal communities were located along the banks
of the Chesapeake Bay and its tributaries at the time that Europeans first
arrived in this area, in the late 16th century. The yellow highlights suggest
where the populations were most concentrated, and the larger communities
are labeled. During the decades that followed their first contact with
Europeans, these original populations were considerably diminished
by war, disease, and land seizures.

Putting NMAI on the Map:

The Chesapeake Bay Watershed

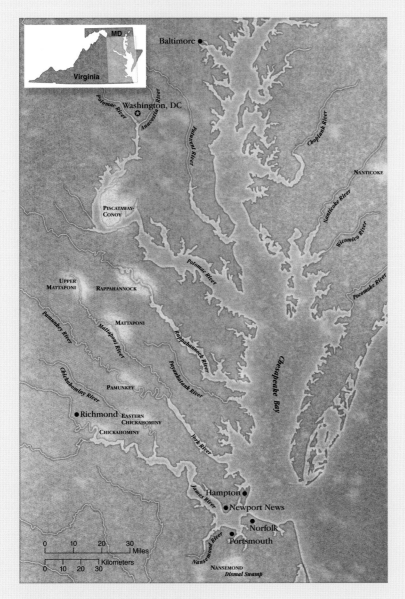

Native Communities Today

Today a number of Native Americans, descendants of the original citizens of the region, continue living, working, and raising their families in communities throughout the Chesapeake Bay area. Some of the more prominent communities are indicated here.

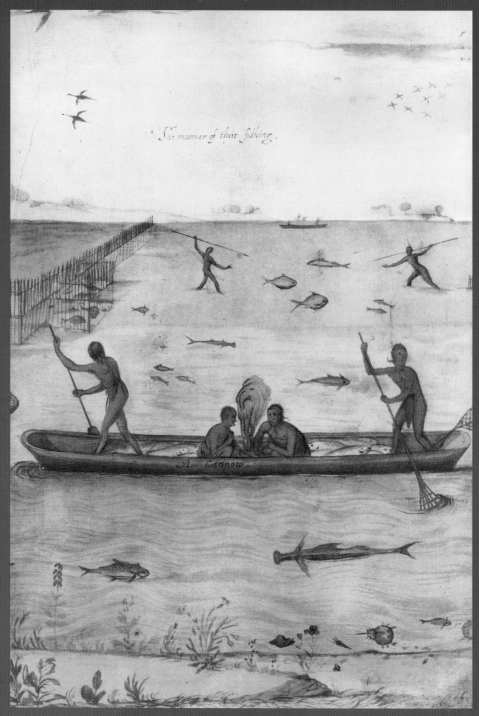

The manner of their fishing.

A Cannow

This ca. 1685 illustration by English artist John White shows Native people from the Chesapeake Bay area fishing from a dugout canoe. White's watercolors are among the most important early records of Native life in the region.

"The earth is still here. The water is still here. And we are still here."

—Chief Billy Redwing Tayac (Piscataway), NMAI Groundbreaking Ceremony, 1999

RETURN TO A NATIVE PLACE:

THE INDIGENOUS PEOPLES OF THE CHESAPEAKE

The deep reality underlying the entire Western Hemisphere is that this is a Native place. Washington, D.C., is a Native place, as is the Potomac River which embraces its lands.

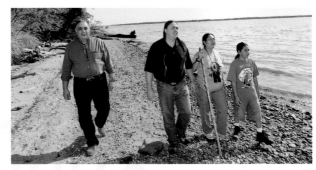

Three generations of the Tayac family (l-r: Billy, Mark, Joyce, and Naiche) walk together along the Potomac River.

For thousands of years, indigenous peoples have made their homes along the Potomac and other river tributaries to the Chesapeake Bay. Archeologists estimate that we have occupied the area for about 11,000 years, but Native peoples believe that the Creator brought us here long before that, in mythic time. We have strong connections both to the land and the water. In the Native conception, rivers are not boundaries that divide people; rather, they bring us together.

The tribes of the Chesapeake Bay region's coastal plain are Algonquian, and all part of the same language family. At the time of the European settlement at Jamestown in 1607, many Native peoples were organized into thriving chiefdoms—affiliations of numerous tribes to one central chief's town, which served as a center of government. Within 100 years after English occupation, our populations were decimated by war, disease, and land seizures.

But some of our peoples, through determination and sacrifice, survived over the centuries and have been quite active since the 19th century. Today there are contemporary Powhatan, Piscataway, and Nanticoke communities finding new ways to fit ancestral identities into a modern world. There are many throughout the Chesapeake region who seek to connect to their indigenous roots again. Along with the land and the water, we are still here. This ancient Native place has been reclaimed.

—Gabrielle Tayac (Piscataway)

11

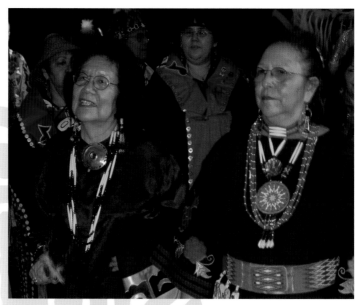

Dottie Tiger (Sac and Fox/Yuchi) and Francine Worthington (Kiowa)
at the Indian Health Service Head Start Powwow, Washington, D.C.

INDIANS IN D.C. TODAY

Change is inherent in the nature of any community, Native or not. Children are born and grow up and have children of their own; people die or move away from the community or decide to join it. A number of American Indian tribes, descendants of those peoples who inhabited the Washington area at the time of first contact with Europeans, still live today in Maryland, Virginia, and Delaware, while a growing urban Indian community, the result of a migration of individuals from many different tribes, has sprung up in Washington in the last several decades.

More than most places, Washington is a town largely populated by people who were not born here. Its American Indian community is fairly well educated, well employed, and stable, with many individuals drawn here by work for federal agencies such as the Bureau of Indian Affairs or Indian Health Service, or non-profit organizations such as the Native American Rights Fund or the National Indian Education Association. Famous for building many of New York's skyscrapers, Mohawk iron workers continued that tradition in D.C. by helping construct the Washington Metrorail system. Native Americans currently hold the honor of serving in the U.S. military in larger numbers, per capita, than any other group. Roughly one-fourth of the staff of the National Museum of the American Indian is Native; many of these staff members moved to Washington specifically to work for the museum. Many Native people

I know have, upon finishing the work that brought them to D.C., ended up staying instead of returning to their original tribal communities. When they do return, many go home alone, because their children and grandchildren have established their own roots in this urban Indian community.

The Civil Rights Movement had an important effect on American Indians and, the American Indian Movement. Other groups came not to protest but to lobby Congress or press various federal agencies for better treatment of Native people.

More recently, hundreds of young American Indian college students have come to Washington every summer as interns, their numbers increasing each year. While in D.C. they work and study,

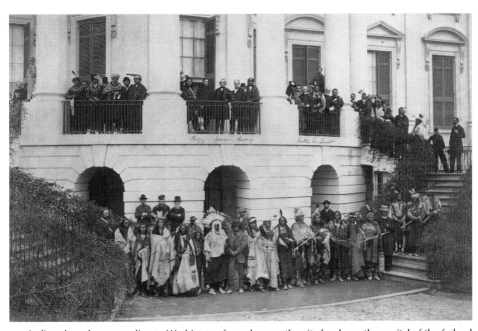

Indians have been traveling to Washington for as long as the city has been the capital of the federal government. Even though most treaties were negotiated in Indian Country, many delegations of tribal members visited D.C. to represent their communities. In this photo from 1867, delegates from the Yankton, Santee, Upper Missouri Sioux, Sac and Fox, Ojibwe, Ottawa, Kickapoo, and Miami tribes pose with President Andrew Johnson on the steps of the White House. (P10142)

in the mid-1960s, tribal people from communities out West began to come to Washington as part of protest groups. Indians joined the Poor People's Campaign—a group organized by Martin Luther King, Jr., to unite impoverished people from different races and backgrounds—and formed groups such as the Trail of Broken Treaties, affiliated with

receiving school credit for their efforts. The interns often join together to celebrate the end of their sojourn in Washington with a powwow at American University, although for some, this will be the beginning of their lives as members of the Indian community in D.C.

—Mitchell Bush (Onondaga), President Emeritus, American Indian Society

For one man, what began as a simple interest in "aboriginal art" developed into a near obsession, eventually resulting in the most extensive collection of Native American art and artifacts in the world. George Gustav Heye (1874–1957) was born in New York City to a wealthy family and graduated from Columbia College in 1896 with a degree in electrical engineering. While on a work assignment in Arizona, Heye (pronounced HIGH) acquired a Navajo deerskin shirt, sparking his lifelong passion for collecting Indian artifacts.

Heye began traveling the country, buying up Native American objects from tribes, villages, and dealers, and shipping them— sometimes by the traincar-load—back to New York. His interest was not limited to the rarest or most significant pieces from a given tribe; rather, Heye would buy entire households full of objects, from the major to the mundane. Heye also traveled to Europe and purchased early examples of Native American art from other collections.

Heye did not confine his collecting to objects. Early on, he recognized that photographs would be an important way to document the cultures of Native peoples, and sought out photographers who had traveled throughout North and South America capturing Native lifeways. Heye sponsored expeditions to the farthest reaches of the Western Hemisphere, sometimes traveling with the anthropologists and photographers he had hired. He bought not only prints but lantern slides and even glass-plate negatives, amassing a collection that today has grown to 125,000 photographic images.

HISTORY OF THE NATIONAL MUSEUM OF THE AMERICAN INDIAN COLLECTION

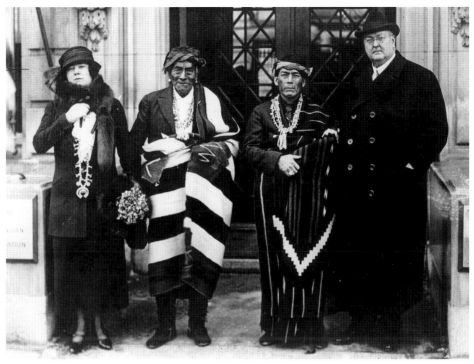

George Gustav Heye and his wife, Thea, with a Zuni delegation in front of the 155th Street museum, ca. 1923. (N08130)

Heye's ever-expanding bounty was initially stored in his Madison Avenue apartment and later in a rented space. In 1916 he established the Museum of the American Indian, Heye Foundation, and in 1922 opened a new building in Manhattan at 155th Street and Broadway to the public. The Museum of the American Indian offered tourists and New Yorkers alike a rare glimpse into the lives of Native Americans. Eventually, the collection spilled over into a warehouse in the Bronx, known as the Research Branch, where scholars, researchers, and Native people were encouraged to share information about the objects housed there. Heye had personal contact with some of the Native people from whom he collected. In 1938, the Hidatsa of North Dakota gave him the name of Isatsigibis, or "Slim Shin," when he returned a sacred bundle to the elders of the tribe.

Heye served as director of his museum until 1956. In 1989, the Museum of the American Indian became part of the Smithsonian Institution by an act of Congress. In 1994, the museum opened its George Gustav Heye Center, located in the historic Alexander Hamilton U.S. Custom House in lower Manhattan. The museum's vast collections, once stored at the Research Branch, have been relocated to the Cultural Resources Center, a state-of-the-art research facility in Suitland, Maryland, just six miles from the museum on the National Mall.

—Danyelle Means (Oglala Lakota)

A NEW MUSEUM IS BORN:
THE SMITHSONIAN NATIONAL MUSEUM OF THE AMERICAN INDIAN

In 1989, Congress passed Public Law 101-185, sponsored by Senator (then Congressman) Ben Nighthorse Campbell (Northern Cheyenne) of Colorado and Senator Daniel Inouye of Hawaii, establishing the National Museum of the American Indian as part of the Smithsonian Institution. The law provided for the transfer of assets of the Heye Foundation and appropriated funds for the construction of facilities at three sites: the Alexander Hamilton U.S. Custom House in New York City, the Cultural Resources Center at Suitland, Maryland, and a new museum on the National Mall in Washington, D.C.

One Hundred First Congress of the United States of America

AT THE FIRST SESSION

Begun and held at the City of Washington on Tuesday, the third day of January, one thousand nine hundred and eighty-nine

An Act

To establish the National Museum of the American Indian within the Smithsonian Institution, and for other purposes.

Be it enacted by the Senate and House of Representatives of the United States of America in Congress assembled,

SECTION 1. SHORT TITLE.

This Act may be cited as the "National Museum of the American Indian Act".

SEC. 2. FINDINGS.

The Congress finds that—
(1) there is no national museum devoted exclusively to the history and art of cultures indigenous to the Americas;
(2) although the Smithsonian Institution sponsors extensive Native American programs, none of its 19 museums, galleries, and major research facilities is devoted exclusively to Native American history and art;
(3) the Heye Museum in New York, New York, one of the largest Native American collections in the world, has more than 1,000,000 art objects and artifacts and a library of 40,000 volumes relating to the archaeology, ethnology, and history of Native American peoples;
(4) the Heye Museum is housed in facilities with a total area of 90,000 square feet, but requires a minimum of 400,000 square feet for exhibition, storage, and scholarly research;
(5) the bringing together of the Heye Museum collection and the Native American collection of the Smithsonian Institution would—
(A) create a national institution with unrivaled capability for exhibition and research;
(B) give all Americans the opportunity to learn of the cultural legacy, historic grandeur, and contemporary culture of Native Americans;
(C) provide facilities for scholarly meetings and the performing arts;
(D) make available curatorial and other learning opportunities for Indians; and
(E) make possible traveling exhibitions to communities throughout the Nation;
(6) by order of the Surgeon General of the Army, approximately 4,000 Indian human remains from battlefields and burial sites were sent to the Army Medical Museum and were later transferred to the Smithsonian Institution;
(7) through archaeological excavations, individual donations, and museum donations, the Smithsonian Institution has acquired approximately 14,000 additional Indian human remains;
(8) the human remains referred to in paragraphs (6) and (7) have long been a matter of concern for many Indian tribes,

CONSULTATIONS AND PREPARATION

The establishment of NMAI within the Smithsonian Institution ended years of uncertainty and debate among Indians, museums, and the general public about the future of one of the world's great collections of objects and archival materials related to the Native peoples of the Western Hemisphere. It also opened a period of planning as to what the mission, programs, and physical spaces of the new museum ought to be, and how it would interact with both its sister institutions and with Native communities throughout the Americas.

Beginning in the early 1990s, NMAI commenced what would be the first of hundreds of conversations with Indians throughout the Western Hemisphere about how the museum should present the stories and customs of their communities. Through what was and continues to be learned from these close relationships with Native communities, the museum seeks to address and reach beyond misconceptions and stereotypes of Native American cultures and peoples and to illuminate how Native Americans perceive their place—spiritually, historically, and physically—in the universe. These dialogues, which have informed the design of the museum building and the content and philosophy of the museum's exhibitions and public programs, enable visitors to understand what it means to be welcomed to a Native place.

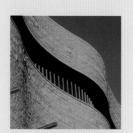
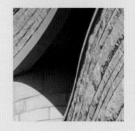

BUILDING A
NATIVE PLACE

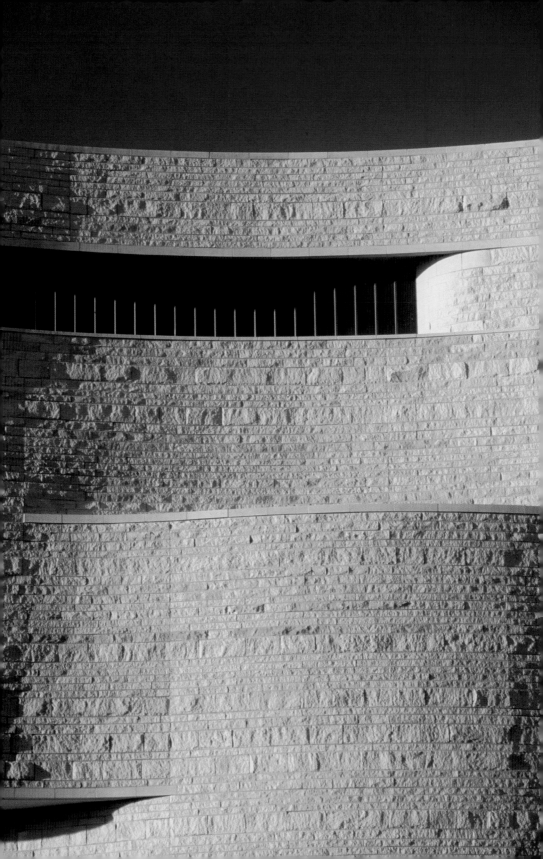

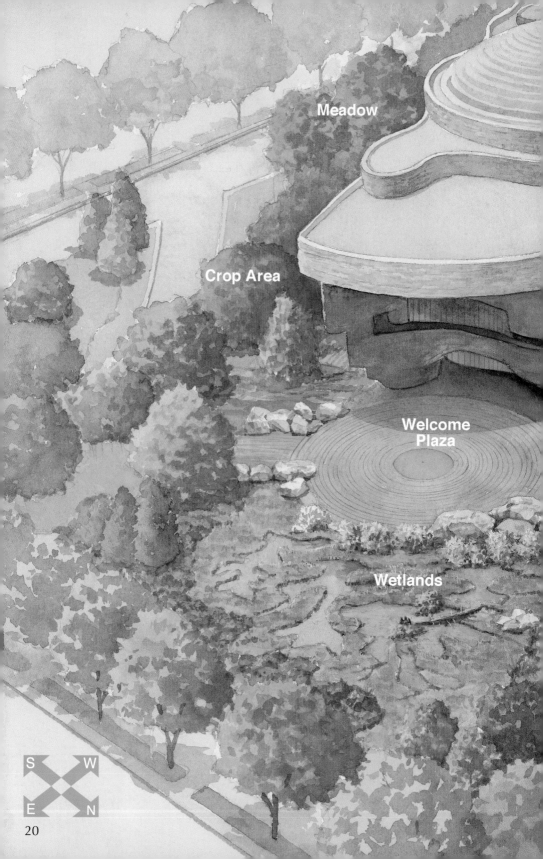

Meadow

Crop Area

Welcome Plaza

Wetlands

S W
E N

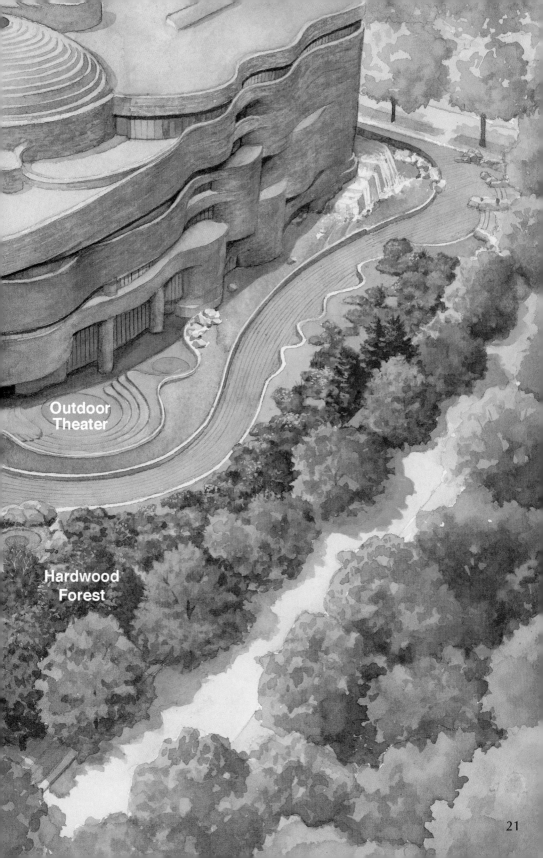

Outdoor
Theater

Hardwood
Forest

21

"Until you realize that you are the flowers and the meadows and the forest and the mountains around you, you will not know who you are."
—Indigenous elder, as quoted by Donna House (Navajo/Oneida, NMAI consultant)

THE NATIVE LANDSCAPE

Native people believe that the earth remembers the experiences of past generations. The National Museum of the American Indian recognizes the importance of indigenous peoples' connection to the land; the grounds surrounding the building are considered an extension of the building and a vital part of the museum as a whole. By recalling the natural environment that existed prior to European contact, the museum's landscape design embodies a theme that runs central to NMAI—that of returning to a Native place.

More than 33,000 plants of 150 species can be found throughout the landscape and its four habitats.

Forest

A forest environment runs along the northern edge of the museum site. Forests have provided indigenous cultures with important materials for shelter, firewood, medicines, and other purposes. More than 25 tree species are included in the forest, including red maple, staghorn sumac, and white oak.

Narrow-leaved cattail

Wetlands

Culturally important to many tribes, wetlands are rich, biologically diverse environments. Wild rice, morel mushrooms, marsh marigolds, cardinal flowers, and silky willows are among the species planted at the eastern end of the museum site.

Magnolia blossom

Meadow

Buttercups, fall panic grass, and sunflowers are among the plants featured in the meadow, located southwest of the museum building.

Swamp milkweed

Traditional Croplands

This area on the south side of the building features medicinal plants and some of the food crops that Native peoples have given to the world, including the "Three Sisters"—corn, beans, and squash. The plants in this area are cultivated using traditional Native agricultural techniques.

Squash blossom

GRANDFATHER ROCKS

More than 40 large uncarved rocks and boulders, called Grandfather Rocks because they are the elders of the landscape, welcome visitors to the museum grounds and serve as reminders of the longevity of Native peoples' relationships to the environment. The Grandfather Rocks, hewn by wind and water for millions of years, were selected from a quarry area in Alma, Canada. The boulders were blessed in a special ceremony by the Montagnais First Nations group prior to their relocation, to ensure that they would have a safe journey and carry the message and cultural memory of past generations to future generations. Upon arriving in Washington, the boulders were welcomed to their new home in a blessing by a member of the Monacan Nation of Virginia.

CARDINAL DIRECTION MARKERS

A subtle yet significant design concept, the Cardinal Direction Markers are four special stones placed in the museum grounds along the north-south and east-west axes. These axes intersect inside the building at the center of the Potomac area of the museum, linking the four directions and their markers to the circle of pipestone that marks the figurative heart of the museum. The markers also serve as metaphors for the indigenous peoples of the Americas. The stones have traveled from the far reaches of the hemisphere in collaboration with their Native source communities: Hawaii (western marker stone); Northwest Territories, Canada (northern stone); Great Falls, Maryland (eastern stone); and Punto Arenas, Chile (southern stone).

23

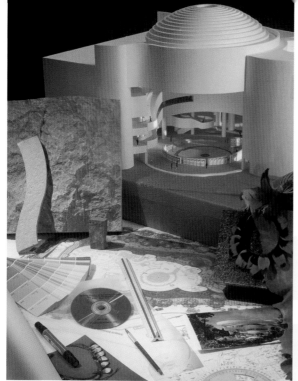

"The building must have a language of its own, a language that speaks for the aboriginal peoples of the Americas, a language that wraps the visitor in a different paradigm of perception."
—NMAI document, 1996

SHAPED BY WIND AND WATER

For many Native peoples of the Western Hemisphere, significant and sometimes spiritual places are often part of the natural world, such as rock formations, lakes, rivers, forests, canyons, and mountains. These kinds of natural settings—as well as the stone and masonry work of Chaco Canyon, Machu Picchu, and other Native sites—inspired NMAI building designers to create a museum and landscape that welcome visitors to a distinctly Native place, one that reflects and honors the organic and emphasizes that people are part of a larger natural world.

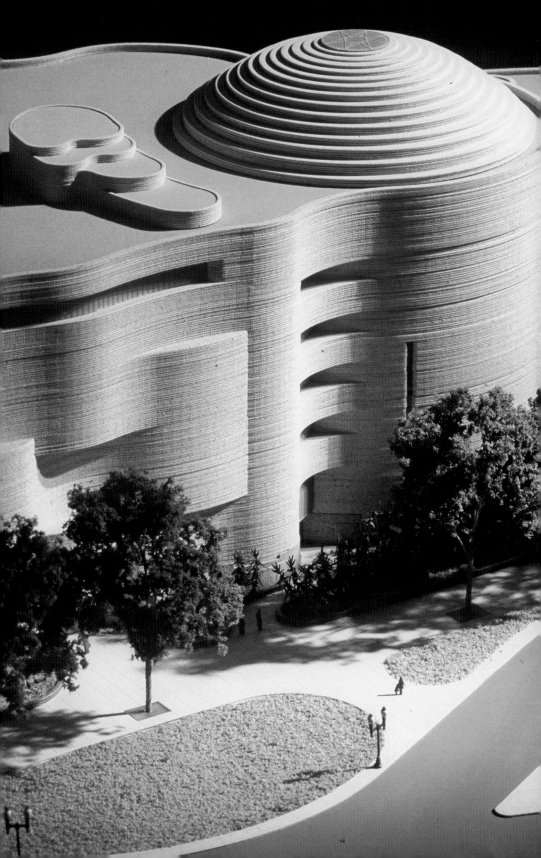

"As tribal people of the Western Hemisphere, we are wonderfully diverse yet essentially similar. We honor the exquisite variety of each other's lifeways, yet recognize that we have some common principles that are essential in the representation and interpretation of our respective ways of being. The museum's designs and operations will be guided by these principles."

—Rina Swentzell (Tewa/Santa Clara Pueblo), Preamble to *The Way of the People*, 1993

THE ARCHITECTURAL DESIGN PROCESS

Beginning in the early 1990s, NMAI opened dialogues with Native communities and individuals across the hemisphere. These early meetings resulted in the museum's landmark document *The Way of the People* (1993), which reached beyond the basic requirements of the building to incorporate Native sensibilities throughout the museum building.

A series of themes emerged from the dialogues. One involved the intuitive nature of the building: it needed to be a living museum, neither formal nor quiet, located in close proximity to nature. Another was that the building's design should make specific celestial references, such as an east-facing main entrance and a dome that opens to the sky. Many comments expressed the desire to bring Native stories forward through the representation and interpretation of Indian cultures as living phenomena throughout the hemisphere.

Some basic parameters for the building structure were dictated by the 4.25-acre trapezoidal site, the building restrictions for the National Mall, and an active creek bed flowing below the

site. These challenges were addressed initially by the design team of GBQC and Douglas Cardinal, Ltd., which included consultants Douglas Cardinal (Blackfoot), Johnpaul Jones (Cherokee/Choctaw), Donna House (Navajo/Oneida), and Ramona Sakiestewa (Hopi). The building's distinctive curvilinear form, evoking a wind-sculpted rock formation, grew out of this early work, forming the basis for the architecture.

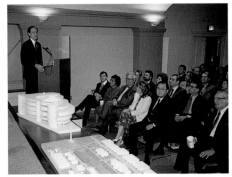

Douglas Cardinal presents design ideas to NMAI Director Rick West (front left), former Smithsonian Secretary I. Michael Heyman (third from left), Senator Daniel Inouye (fifth from left), and other supporters.

Following this conceptual design work, the project was further developed by Jones, House, and Sakiestewa, along with the architecture firms Jones & Jones, SmithGroup in collaboration with Lou Weller (Caddo) and the Native American Design Collaborative, and Polshek Partnership Architects. This extended collaboration resulted in a building and site rich with imagery, connections to the earth, and layers of meaning. The building is aligned perfectly to the cardinal directions and the center point of the Capitol dome, and filled with details, colors, and textures that reflect the Native universe.

The design team was asked to create a palette of colors, materials, symbols, and forms that would imbue the building and site with a Native sensibility. Themes emerged, including abstractions of nature and astronomy. For example, the paving pattern for the Welcome Plaza area outside the east entrance plots the configuration of the planets on November 28, 1989, the date that federal legislation was introduced to create the museum. The center of the plaza is the polestar, Polaris. The museum's south-entry plaza records lunar events, and, inside the building, the Potomac celebrates the sun. The angles of solstices and equinoxes are mapped on the Potomac's floor, and a light spectrum is cast above by the sun shining through prisms set into the south-facing wall.

During the development of the NMAI building, we held close a rich array of images and abstracted Native places. The color palette is heavily inspired by the natural world and the NMAI collection. The cafe drapes itself in the colors and textures of corn, beans, squash, and fish. Objects from the collection lend their hues to areas throughout the building.

I brought my own experiences to the project, and the project in turn has changed me. I feel greatly honored to have been part of this adventure.

—Ramona Sakiestewa (Hopi), Design Consultant

ENTERING THE
MUSEUM

Right:
Sun symbols,
Potomac glass doors

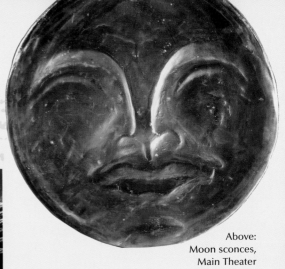

Below:
Copper screen
wall, Potomac

Above:
Moon sconces,
Main Theater

HERE ARE A FEW OF THE UNIQUE DESIGN ELEMENTS OF THE MUSEUM AND WHERE TO FIND THEM

Above:
Adzed
wood,
Museum
Stores

Above:
Bird motifs
representing
the cardinal
directions,
Potomac
elevators

Right:
Shell inlay,
Museum
Stores

GROUND-LEVEL MAP

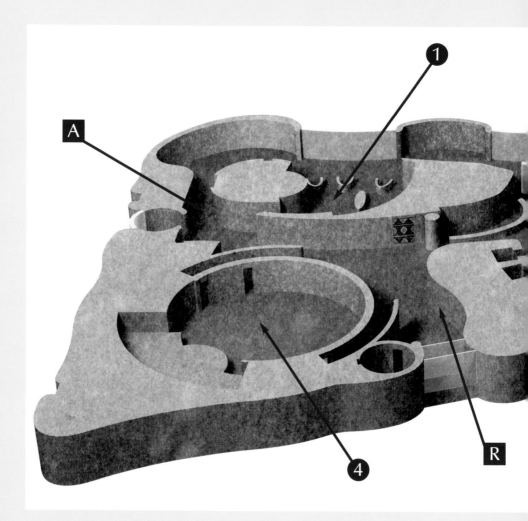

1. Mitsitam Cafe
2. Chesapeake Museum Store
3. Potomac
4. Main Theater

 ATM 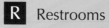 Restrooms

Public restrooms and telephones and the Roanoke
Museum Store are located on the Second Level.

 Elevators Telephones

Dequite Nuegambi
(Kuna)

Apc oc knomiyulpa!
(Maliseet)

Wayt' hust' shal'halt'
(Okanagan)

Haho
(Ho-Chunk)

THE WELCOME WALL

Hundreds of written and spoken words meaning "welcome" in Native languages from throughout the Americas are projected onto a 20-foot-wide screen just above the Welcome Desk inside the east entrance to the building. The Welcome Wall is an evolving project, with different languages added regularly.

Imaynalla
(Wari Quechua)

Na-ha, Nee-ee-na-ban
(Gros Ventre [A'aninin])

Boozhoo, Aanii miigwetch qii-bi-zhaayelc
(Ojibwe)

E peva tse vooma tsema
(Cheyenne)

Sengithaamu
(San Juan Pueblo)

Cama'i
(Alutiiq)

LANGUAGE AS A CARRIER OF CULTURE

"[Native elders] value the language partly because it has been physically beaten out of so many people. Fluent speakers have had to fight for the language with their own flesh, have endured ridicule, have resisted shame and stubbornly pledged themselves to keep on talking the talk. My relationship is of course very different. How do you go back to a language you never had?"

—Louise Erdrich (Turtle Mountain Ojibwe), *New York Times*, May 22, 2000

In ways that are both ordinary and transcendent, language allows us to reach beyond the limits of our own experiences and to share in the experiences of others. Not only does it allow us to communicate with those living today, it allows us to connect, through both oral traditions and the written word, with our ancestors and the ancestors of others. In recognizing the power of language both to shape and preserve culture, we can understand how much was lost through the 19th-century attempts to westernize Native people by suppressing the languages they used for joking, telling stories, working, wooing, dreaming, and praying.

Of the estimated 300 Native languages that existed in North America prior to the arrival of Europeans, approximately 175 are spoken today. Linguists predict that, of these, more than 80% will stop being used within the next generation. To lose a language is in many ways to lose a way of thinking, because languages are not passive vehicles for thought, but instead help shape thought. Every language, like every culture and person, has its own complex personality and

unique outlook on the world. In praising the richness of the Ojibwemowin language, noted novelist Erdrich explains, "The word for stone, *asin*, is animate. Stones are called grandfathers and grandmothers and are extremely important in Ojibwe philosophy. Once I began to think of stones as animate, I started to wonder whether I was picking up a stone or it was putting itself into my hand."

While many Native languages are currently at risk of being lost as living languages, preservation efforts are underway in many communities through educational programs that include training teachers, developing curricula, and working with students as young as preschoolers. Organizations such as the Indigenous Language Institute (**www.indigenous-language.org**) are also bringing resources to these efforts. But perhaps the most important and outspoken advocates for preserving Native language are the speakers themselves, people who, like Erdrich, understand the power of joking and thinking and dreaming in Native tongues.

—Amy Pickworth

Copper screen wall (detail), Potomac

THE POTOMAC

Rivers often serve as points of reference and connection for the people who live near them. In building a distinctly Native public space on the National Mall in Washington, D.C., an area that lies between two rivers, the Potomac and the Anacostia, this idea was a major influence.

Early in the consultations with Native communities, it became clear that the museum required a large central gathering place that needed to be more than a simple rotunda; this space should refer to the organization of the Native world and be a place of connection to contemporary Native activity. Further, it should honor the Native people from the Washington area.

The resulting space, the Potomac (from the Algonquian/Powhatan word meaning "where the goods are brought in"), is the point of entry for most visitors and a venue for a variety of performances and other cultural exchanges. Soaring 120 feet to the top of the dome and spanning more than 100 feet in diameter, the Potomac is the very heart of the museum building, the sun of its universe, and celestial references abound.

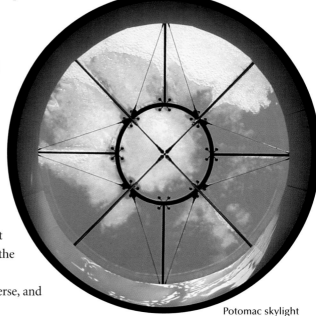

Potomac skylight

Facing east to greet the morning sun, the main doors opening into the Potomac are etched with sun symbols from Native cultures. An oculus in the dome five stories above the space provides views of the sky. Inlaid in the floor at the center of the Potomac is a disk of red pipestone, its design an abstraction of fire, quarried in Minnesota and finished by hand by Travis Erickson (Sisseton Wahpeton Sioux). From this circle, the four cardinal directions extend to views out of the building, and the axes of the solstices and equinoxes are mapped on the floor with rings of red and black granite. Eight large glass prisms glitter from a window in the south wall, each sited to the sun for a particular time of day and season. A wall of woven copper bands encircles the Potomac. Textured with a solar pattern, this dramatic screen evokes the weaving traditions of Native basketry and textiles. Elevators leading to the exhibition areas feature different bird motifs that refer to flight and the cardinal directions.

—Linda R. Martin (Navajo)

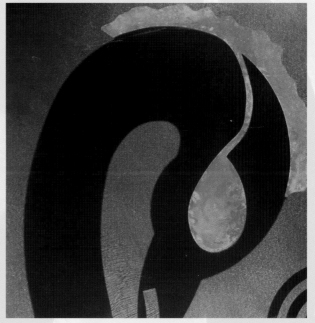

Bird motif, Potomac elevator doors

The Potomac area contains a Welcome Desk with visitor and membership information.

Timed passes, a limited number of which are distributed each day at the east entrance of the museum, are required to enter the building.

Museum passes may be secured in advance through www.tickets.com, or by phoning 1-866-400-NMAI (6624).

35

"When I build a canoe, the canoe is in charge of the timing. You can't rush these things. You have to do it with respect. My ancestors talk to me through the canoe; I hear the voices of the old folks."

—Earl Nyholm (Ojibwe)

Bill Martin (Makah), carved and painted wood paddle, 1991. (25/3355)

NATIVE AMERICAN BOATBUILDING TRADITIONS

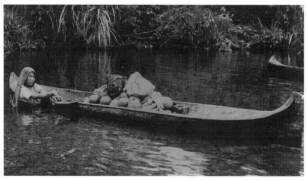

Kuna woman transporting bundles by canoe, 1938. Rio Diablo, Panama. (N25435)

In many contemporary Native communities, the revival of boatbuilding traditions has become a focal point for cultural renewal. A celebration of this revival is the opening theme for the museum's Potomac area. Through 2006, many different types of vessels—from birchbark and Native Hawaiian canoes to the totora-reed boats of the Aymara people of Bolivia and Peru and the elaborately carved boats of the Northwest Coast—will be constructed in the Potomac by master Native boatbuilders and their apprentices. Hands-on activity tables allow visitors to try out boatbuilding skills such as hide-scraping and birchbark-lacing, and multimedia stations offer videos of boatbuilding activities and links to websites. A variety of public programs related to boats and navigation are slated, including music and dance performances, storytelling, lectures, and craft demonstrations.

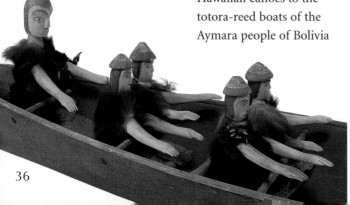

Makah model with wooden figures, attributed to Young Doctor, ca. 1900. Wood, cedar bark, bear skin, paint. Neah Bay, Washington. (6/8874)

PUBLIC PROGRAMS

In showcasing the history and cultural expression of indigenous peoples of the Americas, including Native Hawaiians, NMAI public programs present a variety of engaging educational activities. Native presentations, stage plays, dance and music performances, demonstrations, lectures, film screenings, symposia, and seminars are held in indoor and outdoor spaces, including the Main Theater, the Outdoor Amphitheater, and the Potomac area, as well as in classrooms and the Conference Center. The museum's Resource Center also provides access to Native cultures and NMAI's collection through computers, audio-visual materials, books, and hands-on experiences.

NMAI's Film and Video Center, located in New York and Washington, D.C., is dedicated to presenting and disseminating information about the work of Native Americans in media. The center hosts film festivals, screenings, and symposia, and maintains a website, **www.nativenetworks.si. edu**, that provides news, calendar listings, and other resources.

—Linda R. Martin (Navajo)

NMAI's website, **www.AmericanIndian.si.edu**, lists details about exhibitions and events, offers access to teacher materials and resources, and gives information about internship and employment opportunities for students and professionals.

The website also provides information on ordering a variety of books and recordings produced by the publications department of NMAI, including award-winning exhibition-related, special-interest, and children's book titles.

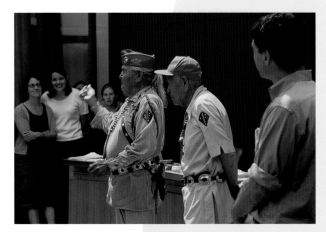

Some American Indian soldiers, known as codetalkers, protected sensitive material in time of war by translating it into Native languages. World War II codetalkers Joe Kellwood (left) and Arthur J. Hubbard, Sr. (both Navajo), visited NMAI to tell their stories and sign books.

MAIN THEATER

The National Museum of the American Indian is filled with visual metaphors that ground the building in the Native world. From the initial concept to its final touches, the theater design was inspired by the metaphor of a perfect storytelling venue: a clearing in the woods under a bright night sky.

Native stories are often told in winter or at night, and visual references to this setting include the moon, the texture of ice, colors used by the Inupiaq people of Alaska, and Raven, a trickster character often found in American Indian stories. Vertical wood paneling surrounds the 322-seat circular theater, evoking a dense hardwood forest, and above, a dark blue ceiling twinkles with constellations. Cast-glass sconces along the back wall recall the phases of the moon.

This gathering place brings visitors close to Native performers by incorporating a unique lateral aisle that allows performers to move from the stage through the audience in full circle, consistent with many Native dances. Equipped with multi-media projection systems, language-translation systems, and superb acoustic qualities, the theater hosts a diverse program of Native musicians, theater companies, dancers, film festivals, and storytellers.

Kwakiutl carved figure, ca. 1880. Wood, paint. Vancouver Island, British Columbia. (11/5244)

MUSEUM STORES

Located on the ground level on the western edge of the Potomac space, the Chesapeake Museum Store features jewelry, textiles, and other works by Native artisans. The design of the store itself incorporates the handiwork of contemporary Native artists, with surfaces built of cedar and alder and adzed by master carvers. Fine purple and white tiles were crafted from Quahog shells and inlayed in the display benches by members of the Wampanoag tribe of Martha's Vineyard, Massachusetts. The word "Chesapeake" is the name that local Native peoples gave the bay, meaning "great shell bay" or "mother of waters."

Beside the Potomac staircase, a 20-foot-tall totem pole carved by Tlingit artist Nathan Jackson links the first-level Chesapeake Museum Store with the second level's Roanoke Store. Overlooking the Potomac area and featuring a view of the National Mall, the Roanoke Store offers a wide variety of merchandise, including

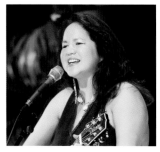

Performers such as Joanne Shenandoah (Oneida) are regularly featured at the Main Theater.

crafts, books, music, souvenirs, and toys. Roanoke, now chiefly known as the name of a town in Virginia, originally meant "shell of lesser value." It referred to the white shell beads—less highly valued than purple beads—found in the wampum strings some East Coast tribes used for exchange and formal communication.

MITSITAM CAFE

Mitsitam (mit-seh-TOM) means "let's eat" in the Piscataway and Delaware language. The Mitsitam Cafe, located on the museum's ground level, offers meals and snacks based on the indigenous foods and culinary traditions of the Americas. Visitors may be surprised at both the variety of regional cuisines and the number of familiar foods that have their roots in Native agriculture. This soaring two-story dining space overlooks the water feature that winds along the north side of the building.

THE IMPORTANCE OF NATIVE FOODS

For most indigenous cultures of the Western Hemisphere, food is not only a source of physical sustenance; the traditions related to securing, sharing, and celebrating food are central to the spiritual well-being of each community. The spiritual significance of food stems from the acknowledgment that the Creator, spirit beings, and animal spirits bestow nourishment for the good of the people.

A Lakota philosophy, *mitakuye oyasin*, "we are all related," recognizes that humankind shares the earth as partners with our animal relatives. A universal belief among indigenous peoples is that plants and animals offer themselves up to us so that we may live. They sustain, clothe, protect, and give us special powers. In return, it is up to us to respect and honor them, and to thank them for their sacrifice.

Expressed through ceremonies, reverence for the Creator and our plant and animal relatives permeates the traditions, philosophies, values, and cycles of Native life. If performed faithfully and humbly, these ceremonies ensure successful hunts, plentiful harvests, and natural order.

Creative expression is another form of reverence. Many of the objects and performances seen at NMAI— whether Inka *q'iru* (goblets) for drinking chichi, Numakiki (Mandan) painted buffalo robes, or the Corn Maiden dance of the San Juan Pueblo—are cultural expressions that honor or embody our reliance upon the Creator and spirit beings for food.

In the traditions of giving thanks, food is the bond that fosters good relations. Expressions of generosity, humility, and gratitude reach enormous proportions in Native communities at times of feasts, celebrations, and other community gatherings. The offering of food is a central gesture of hospitality. *You are welcome here. Eat with us, visit with us. Celebrate. Mitsitam!*

—Linda R. Martin (Navajo)

EXHIBITIONS:
ENTERING THE
NATIVE WORLD

Right: Children in the town of Santa María,
Huatulco, Mexíco, celebrating Quatro Viernes
(the Fourth Friday of Lent), 1998.

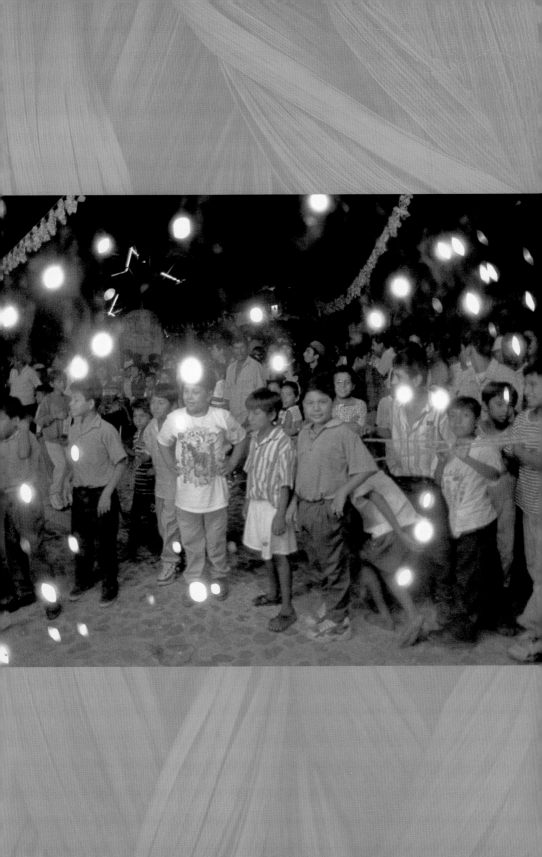

FOURTH-LEVEL MAP

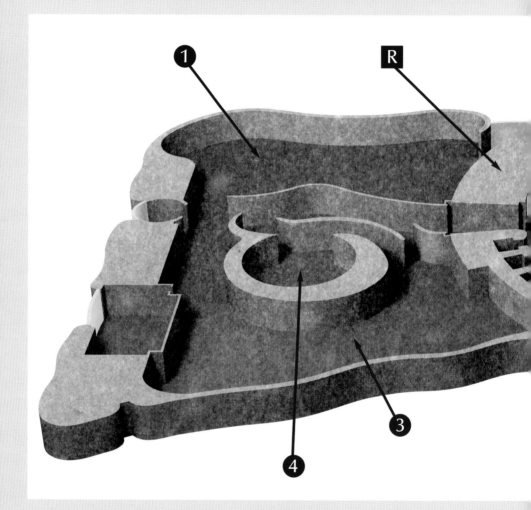

1 Our Peoples
2 Window on Collections
3 Our Universes
4 Lelawi Theater

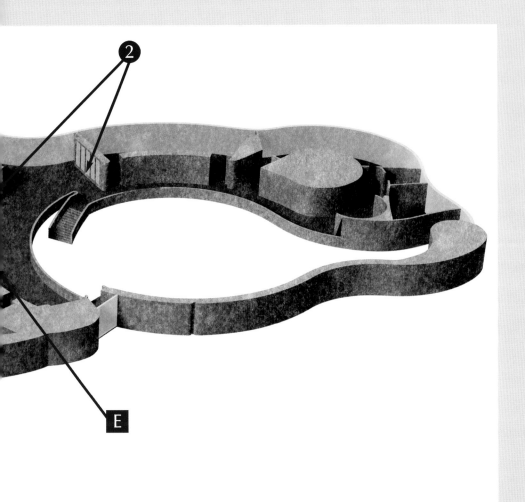

R Restrooms E Elevators

Inupiat whaling crew watching for bowhead whales. Barrow, Alaska

LELAWI THEATER

The 125-seat circular Lelawi (leh-LAH-wee) Theater, located adjacent to the *Our Universes* gallery on the fourth level, offers a dazzling multi-media experience designed to prepare museum-goers for the themes and messages they will encounter during a visit to NMAI. *Who We Are*, a 13-minute presentation, immerses viewers in the vibrancy and diversity of contemporary Native life and explores, from a Native perspective, the strength that different communities across the hemisphere derive from their connections to land, community, religion, self-government, and self-expression.

Pipemaker Travis Erickson (Sisseton Wahpeton Sioux) in his studio. Pipestone, Minnesota

Teotihuacán, Mexico

Overhead, images fill the 40-foot dome, transporting viewers to the vast reaches of the Arctic, the cool forests of the Northwest Coast, and the high plateaus of Bolivia. A four-post center structure supports four additional screens, and emerging from the floor is a cast-acrylic "rock" that transforms from a rushing creek to a storyteller's fire. Surrounding visitors are objects from the collection that link to the stories. Among the tribal groups highlighted in the presentation are the Mi'kmaq (east), the Maya and Aymara (south), the Inupiat and Haida (north), and the Hopi, Lakota, and Muscogee Creek (west).

Hopi, Arizona

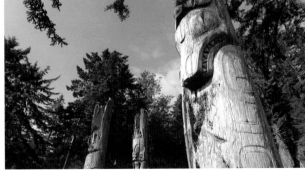

Totem poles at Haida Gwaii. Queen Charlotte Islands, Canada

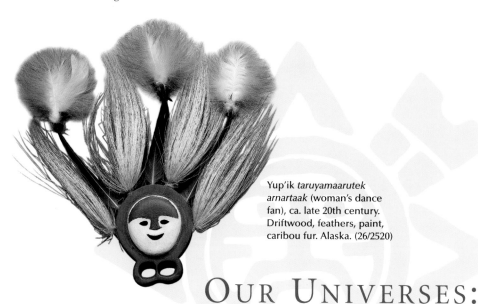

Yup'ik *taruyamaarutek arnartaak* (woman's dance fan), ca. late 20th century. Driftwood, feathers, paint, caribou fur. Alaska. (26/2520)

OUR UNIVERSES:
TRADITIONAL KNOWLEDGE
SHAPES OUR WORLD

The first of NMAI's three main exhibitions, *Our Universes* focuses on Native cosmology—worldviews and philosophies relating to the creation and order of the universe—and the spiritual relationship between humankind and the natural world. Organized around one solar year, the exhibition explores annual ceremonies as a window to ancestral Native teachings. Visitors discover how celestial bodies shape the daily lives, and establish the calendars of ceremonies and celebrations, of Native peoples today.

Our Universes explores the Denver March Powwow, the North American Indigenous Games, and the Day of the Dead as seasonal celebrations that bring together different Native peoples. Eight inaugural Native communities—Pueblo of Santa Clara (New Mexico), Anishinaabe (Canada), Lakota (South Dakota), Quechua (Peru), Hupa (California), Q'eq'chi' Maya (Guatemala), Mapuche (Chile), and Yup'ik (Alaska)—share tribal philosophies in distinctive community-curated sections of the exhibition. The structure of each of these galleries reflects each community's own interpretations as to the order of the world.

Hupa hat, ca. 1910. Maidenhair fern, bear grass, pine root, hazel sticks. California. (20/9586)

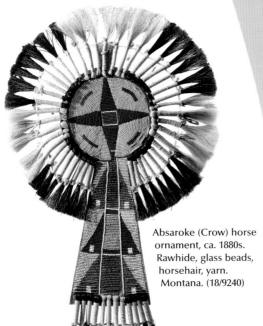

Absaroke (Crow) horse ornament, ca. 1880s. Rawhide, glass beads, horsehair, yarn. Montana. (18/9240)

I am Tlingit and my family is of the Eagle Clan on my mother's side. I live in Seattle.

Raven is the one in our culture who brought order to the world. . . . The bases of all my inspiration are [Tlingit] stories and symbols. All of that imagery is brought into the glasswork. I create objects that represent or try to tell something about the culture of the Tlingit people. The stories are a way of passing on knowledge of all aspects of the world, and teachings, and morals. These stories are really important. . . . Time spent listening to these stories and trying to understand the metaphors that are behind them gives you a lot of insight into life.

—From an interview with Preston Singletary, whose commissioned piece *Raven Steals the Sun* is a highlight of the *Our Universes* exhibition

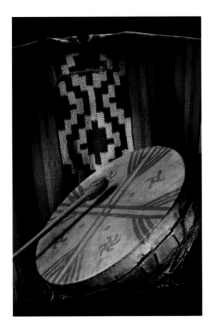

Mapuche *kultrung* (drum) with stick. Wood, leather, horsehair, paint. Chile. (17/5797); Mapuche *makuñ* (poncho), early 20th century. Wool, natural dyes. Chile. (17/6736)

Preston Singletary (Tlingit, b. 1963), *Raven Steals the Sun*, 2003. Blown and sand-carved glass. (26/3273)

47

HOW RAVEN STOLE
THE SUN

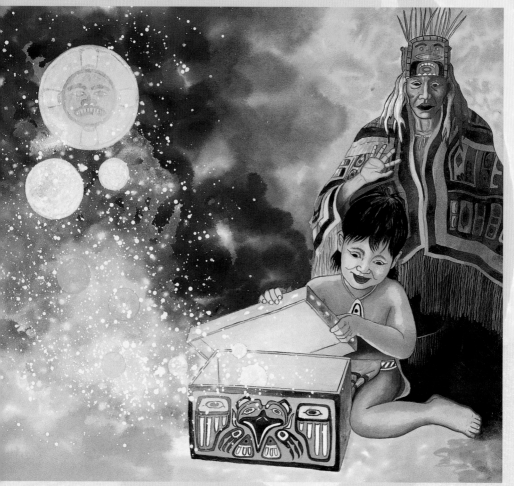

Baby Raven opens the box containing the stars. Painting by Felix Vigil.

A long time ago, Raven, or Yeíl, was pure white, and the world existed in total darkness. The stars, moon, and sun were kept in large, beautifully carved boxes by a greedy chief, and Raven plotted to take them away. He decided to take the form of a small pine needle, and fell into a cup of water drunk by the Chief's beautiful daughter. Several months later she gave birth to a beautiful baby boy. But what the Chief and his family didn't know was that the baby was Raven.

One day the Chief noticed the baby was pointing to the box with the stars in it. He cried and cried for it. Finally the Chief got the box of stars down for his grandson. Raven smiled and played with the box, and when the Chief was not looking, Raven opened it. The stars flew out and up into the sky!

The grandfather was not pleased to lose his stars. But his grandson was happy for a little while, and this made him happy. But eventually Raven began to cry again. He cried and cried and pointed to the box containing the moon. The Chief remembered what happened the last time, but couldn't stand to see his grandson cry, so he handed him the box. The grandson smiled, and when the Chief looked away, he opened the lid. The moon flew out and up into the sky!

Raven loved making mischief, but he was tired of being a baby. He wanted to be a raven again. He missed his glorious

feathers and flying through the air, and he was getting really tired of the Chief. But Raven waited because he was so curious about what was in the last box, the biggest and most beautiful of the three boxes.

And so he began to cry. He cried and cried for days. The Chief remembered what had happened before, but he was sad to see his grandson crying. So he handed him the box containing the sun. Of course cunning Raven was waiting for this moment. He opened the lid and freed the sun. What a beautiful sight! The sun flew out and up into the sky, and daylight came into the people's lives. Raven was very happy, and now that his curiosity was satisfied, he changed back into a raven. The Chief saw the transformation and became very angry. He had been tricked!

Trapped inside the Chief's house, Raven finally squeezed through the tiny smokehole, and emerged completely black! From the tips of his claws to the ends of his wings, every feather and even his beak were a beautiful shiny black. This was how Raven came to be black, as he remains to this day.

—Adapted from *How Raven Stole the Sun* by Maria Williams (Tlingit), with illustrations by Felix Vigil (Jicarilla Apache/Jemez Pueblo), © 2001 NMAI, Smithsonian Institution. Published by NMAI with Abbeville Press.

"We are the evidence of this Western Hemisphere."
—Henry Crow Dog (Lakota), 1974

OUR PEOPLES:
GIVING VOICE TO
OUR HISTORIES

Aztec *Matrícula de Tributos* or Codex Moctezuma (tribute record), ca. 1519. Bark paper, paint. Mexico.

Native peoples, when not left out completely, are often portrayed in textbooks in narrow or inaccurate ways. In *Our Peoples*, American Indians tell their own stories—their own histories—and in this way the exhibition presents new insights into, and different versions of, history. This exhibition encourages viewers to consider history not as a single, definitive, immutable work, but as a collection of subjective tellings by different authors with different points of view. Visitors are invited to question, *What is history and who writes it?* as they look at the last five

While many American Indian cultures tend to pass along their histories through oral traditions, this is not the only way that tribal and individual histories are preserved. This Nahua *matrícula* (opposite, page 50) documents the taxes each Nahua village paid that year to the Aztec government, while a contemporary counterpart (below), *Lucha por las tierras comunales*, tells the story of land struggles within the Nahua community. Less a public record and more a personal expression, objects like this Kiowa shield (left) were often decorated by Plains warriors with images from dreams and other visions.

Kiowa shield, ca. 1890. Rawhide, semi-tanned hide, red wool, rabbit fur, horse hair, sparrow-hawk feathers. Oklahoma. (12/3230)

centuries from the vantage point of eight groups of American Indians. The Seminole (Florida), Tapirapé (Brazil), Kiowa (Oklahoma), Tohono O'odham (Arizona), Eastern Band of Cherokee (North Carolina), Nahua (Mexico), Ka'apor (Brazil), and Wixarika—sometimes known as Huichol—(Mexico) author their own tribal histories, sharing with visitors a few of the multitude of stories that represent American Indian experience.

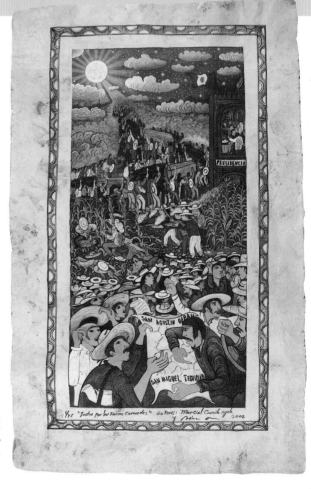

Marcial Camilo Ayala and Nicolás de Jesús (Nahua), *Lucha por las tierras comunales (Struggle for Communal Land)*, 2002. Amate paper, paint. Mexico. (25/9610)

51

OUR PEOPLES:
A HISTORY OF RESILIENCE

Powerful forces have transformed life in the Americas since 1492. Before Columbus's arrival, tens of millions of Native people made their homes here in deserts, on mountains, in fishing villages, and in crowded cities. They spoke hundreds of different languages and lived complex lives as kings, scientists, farmers, artists, cooks, dreamers, hunters, and students. After Columbus and other explorers arrived, American gold made Spain the richest country in the world, while epidemics of diseases introduced by Europeans raged across the hemisphere for 150 years, claiming as many as nine lives out of ten in some Native communities. Those who lived often found themselves pushed out of the lands their people had inhabited for thousands of years.

The arrival of Europeans in the Western Hemisphere set the stage for the most momentous series of events in recorded human history.

It created the world we live in today, reshaping Africa, Europe, and Asia; fueling the rise of capitalism; and changing the clothes humans wore, the food they consumed, and the ideas they exchanged.

In struggling for survival in this new world, every Native community experienced loss in unique ways, but nearly all wrestled with the impact of deadly new weaponry, the weakening of traditional religion and ritual by the Christian church, and the dispossession of traditional lands by other governments. But the story of these last five centuries is not entirely about destruction. It is also a story about resilience; the intentional, strategic adoption of tools and customs by Native peoples in order to keep their cultures alive; and how weaponry, the church, and relationships with other governments have been used by Native peoples to ensure their futures.

Tapirapé men's Parrot Society headdress, ca. 1995. Macaw feathers. Brazil. (26/58)

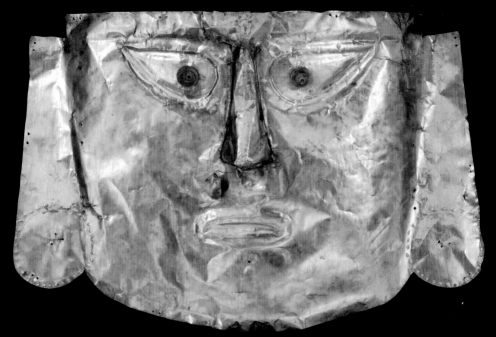

Chimu mask, ca. 1200–1400. Gold, turquoise. Peru. (18/4291)

"O, most excellent gold! Who has gold has a treasure with which he gets what he wants, imposes his will on the world, and even helps souls to paradise."
—Christopher Columbus, in a letter to King Ferdinand and Queen Isabella, 1503

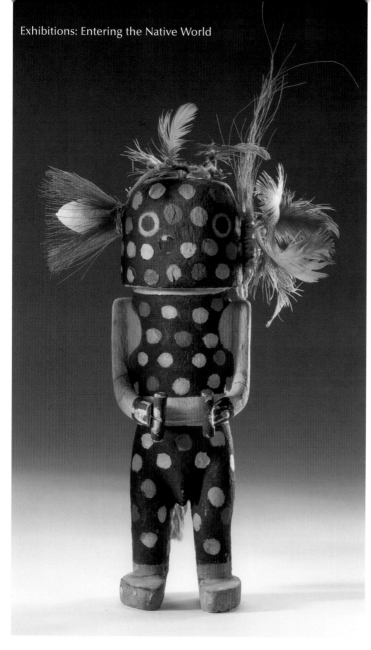

Hopi katsina doll, ca. 1890. Cottonwood root, paint, cloth, feathers, horsehair, string. Arizona. (9/994)

WINDOW ON COLLECTIONS:
MANY HANDS, MANY VOICES

W*indow on Collections* allows visitors a glimpse at the remarkable breadth and diversity of objects from the NMAI collection and gives insight into Native experiences through these material legacies.

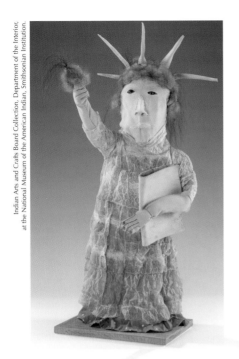

Indian Arts and Crafts Board Collection, Department of the Interior, at the National Museum of the American Indian, Smithsonian Institution.

Rosalie Paniyak (Cup'ik Eskimo), *My Love, Miss Liberty*, 1987. Sea lion intestine overdress, printed fabric underdress, fur, seal hide, wood, blue glass marbles. Alaska. (25/5563)

Thomas Jefferson peace medal, 1801. Belonged to Powder Face (Arapaho). Copper-alloy coin, leather, porcupine quills, feathers, metal. Oklahoma. (24/1965)

More than 3,000 objects from the museum's collection are presented in the *Window on Collections* exhibit, located on the third and fourth levels of the museum. Housed in glass-fronted cases located on the balconies overlooking the Potomac area, inaugural presentations include objects with beads, peace medals, arrowheads and other projectile points, containers, dolls, and objects featuring animals.

Through the use of interactive technology, visitors can enjoy a self-guided learning experience. They may access information about each object; watch video clips of community members and specialists talking about broad categories or particular objects; and, through computerized imagery, electronically zoom in on special details or rotate a variety of objects for 360-degree viewing. Additional information about the objects can also be found at the Resource Center.

Klikitat beaded bag, ca. late 1800s. Glass beads, cotton, wool trade cloth, leather thong. (13/8466)

THIRD-LEVEL MAP

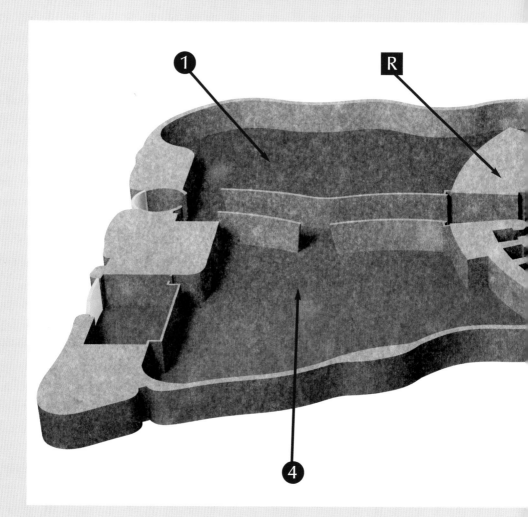

1. Changing Exhibitions
2. Window on Collections
3. Resource Center
4. Our Lives

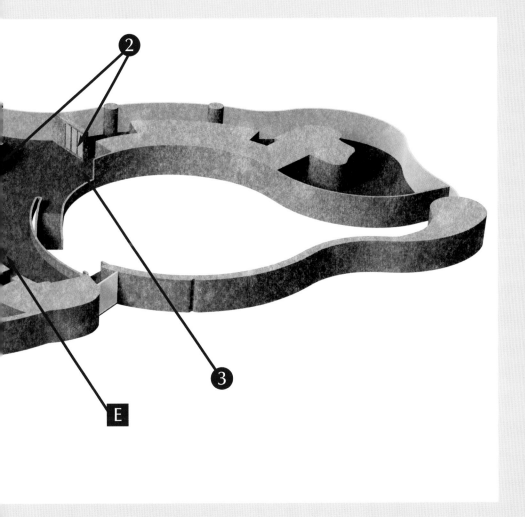

R Restrooms E Elevators

OUR LIVES:
CONTEMPORARY LIFE AND IDENTITIES

Just as they did in 1491, Native Americans today live in a land that is ancient and modern, diverse and always changing. They number in the tens of millions and live in the hemisphere's most remote places and its biggest cities. They fly spacecraft and herd llamas, write software and grow orchids, fight wars and teach chemistry. They trade stocks from Park Avenue apartments, drive taxis through Lima's rush hour, and sell shoes in Kentucky strip malls. Modern American Indians are not shadows of their ancestors, but their equals.

—Paul Chaat Smith (Comanche)

Ann Drumheller and daughter, Patricia (Onondaga)

Tanya Thrasher (Cherokee Nation of Oklahoma)

Justin Bruce Giles (Muscogee Creek Nation [Big Cat Clan])

Miranda H. Belarde-Lewis (Zuni/Tlingit) Ramiro Matos (Quechua)

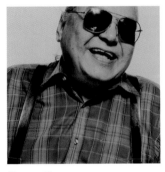

Our Lives examines the identities of Native peoples in the 21st century, and how those identities, both individual and communal, are the results of deliberate, often difficult choices made in challenging circumstances. All people are profoundly influenced by the world around them, by their families and communities, the language they speak, the places they live and identify with, and their own self-determination. This exhibition explores each of these forces in modern Native life, as well as another factor unique to contemporary Indian identity: the continuing resonance of imposed legal policies-—some of which are five centuries old—regarding who is Indian and what that means.

George Horse Capture (A'aninin Gros Ventre)

Eight communities contributed their stories to this telling—the Campo Band of Kumeyaay Indians (California), urban Indian community of Chicago (Illinois), Yakama Nation (Washington State), Igloolik (Canada), Kahnawake (Canada), Saint-Laurent Metis (Canada), Kalinago (Carib Territory, Dominica), and the Pamunkey Tribe (Virginia).

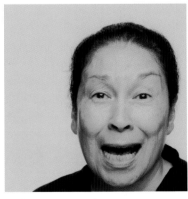
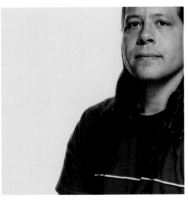

Gayle Yiotis (Pamunkey) Glenn Burlack (Lumbee)

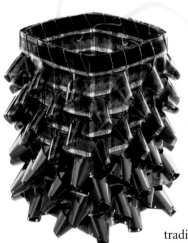

Strawberry basket, 1969. Made by Eve Point (Mohawk). Wicker-plaited natural and dyed black-ash splints with wart-weave overlay, applied splint leaves, sweetgrass rim. (26/1941)

TRADITIONAL TECHNIQUES, CONTEMPORARY ART

Although they have been made by Native people in North America for several thousand years, baskets are, and always have been, contemporary objects, products of the materials, needs, and aesthetic values of the times and cultures in which they were created. Baskets are made for specific purposes, whether for sifting meal, carrying water, storing food, for use in religious ceremonies, or, as is most common in more recent times, for sale. The forms that baskets take, and their shapes and sizes, are typically related to their purpose.

Gail Tremblay (Onondaga/Mi'kmaq, b. 1945), *Strawberry and Chocolate*, 2000. 16mm film and fullcoat. (25/7273)

As Native people recognized the commercial potential of selling objects to tourists and at other non-Native venues, new styles followed. For example, in the mid-20th century, the traditional technique of splint-plait basketry was employed by Ho-Chunk communities in Wisconsin to create new forms: shallow round baskets, perfect for holding blocks of cheese, for sale to local dairy companies.

Traditional basket forms have often been adapted to appeal to the contemporary consumer market, resulting in picnic baskets, fruit baskets, market baskets, or decorative baskets, such as the strawberry basket by Eve Point (Mohawk) seen here.

In a twist on traditional forms—and as a wonderful example of the playfulness often seen in contemporary American Indian art—Onondaga/Mi'kmaq artist Gail Tremblay has wed the splint-plait technique to an unusual material: film. This piece is part of a series by Tremblay, an artist and writer who teaches at Evergreen State College in Olympia, Washington. Some of the films woven into baskets in this series are, ironically enough, old cowboy movies.

This painting is an early work in the *Super Indians* series, produced by Scholder from about 1969 through the late 1970s, when he was teaching at the Institute of American Indian Arts (IAIA) in Santa Fe. Frustrated to find that many of his Native students were still influenced and limited by the hackneyed stereotypes of Indians that dominated films, books, and artwork, Scholder created *Super Indians*. Incorporating ideas from the mainstream art world and Pop Art in particular, Scholder sought to update the idea of Nativeness through these works. The series offers interesting juxtapositions as it explores what it is to be Indian, and the results are often both angry and humorous. Another painting in the series is *Super Indian #2*, which portrays a dancer wearing a buffalo head and eating an ice cream cone.

In *The American Indian*, we are offered an image of a Native man who is elegant and dignified, if somewhat anonymous. The canvas is large, and the subject's bearing suggests the almost regal quality typically seen in portraits of the Founding Fathers. In the late 19th century, surplus American flags were often given to Indian communities. As an expression of respect, these flags were sometimes worn by Native people as blankets would have been. Scholder had previously worked on a project with the Rockefeller Foundation to analyze archival photographs, and the use of the American flag as a mantle as seen here may have been inspired by a photo from that collection.

Fritz Scholder is a very important figure in the history of American Indian art. During a time of tremendous political redefinition within the Native American community, he has taken on the notion of redefining contemporary Indianness through artwork. Scholder has influenced many students, and probably his greatest gift as a teacher and mentor has been to encourage young people to look beyond the stereotypes that limit them as Native Americans, in this way helping them chart new territory as both individuals and artists.

—Truman Lowe (Ho-Chunk)

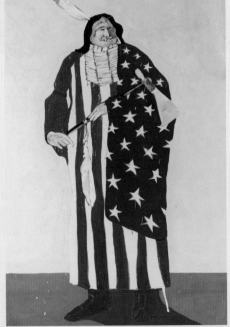

Fritz Scholder (Luiseño, b. 1937), *The American Indian*, ca. 1970. Oil on canvas, 42 x 59 inches. (26/1056)

Indian Arts and Crafts Board Collection, Department of the Interior, at the National Museum of the American Indian, Smithsonian Institution.

RESOURCE CENTER

The Resource Center is a third-level public reference area where visitors learn more about the Native peoples of the Americas and the exhibitions, programs, and collections at NMAI. It is open seven days a week.

The Resource Center is made up of the Interactive Learning Center (ILC), with 18 public-access computers; a work-study area, where adults and children can use Resource Center reference materials and access on-line information; and a classroom, equipped with a large plasma monitor and handling collections. Guided hands-on sessions are available by making an appointment.

Reference collections consist of books, audio, video, interactive CD-ROMs, pamphlets, and hands-on "discovery boxes." Both adult and juvenile titles are included in the book collection, with subjects covering genealogy, history, culture, art, tribal enterprises, and travel to Indian Country. Native-produced curricula are an important part of the collection, and tribal newspapers and periodicals give readers glimpses into contemporary Indian life.

CHANGING EXHIBITIONS

NMAI's Changing Exhibitions gallery showcases temporary exhibitions of Native artworks. The inaugural exhibition for this 8,500-square-foot space is a major retrospective, *Native Modernism: The Art of George Morrison and Allan Houser*. It is expected to be on view until the fall of 2005. Morrison (1919–2000) and Houser (1914–94) laid the foundation for contemporary Native American art and influenced future generations of artists. Before the word "contemporary" began to be associated with American Indians or their art, they experimented with design, form, and color to create modern works that bridged the gap between Native and non-Native audiences.

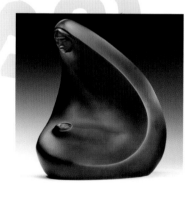

Allan Houser (Warm Springs Chiricahua Apache), *Reverie*, 1981. Bronze. (25/7238)

George Morrison (Grand Portage Band of Chippewa), *Untitled (Horizon)*, 1987. Lithograph. (25/9065)

A NATIVE PATH THROUGH D.C. — OTHER POINTS OF INTEREST

The Washington area offers many places of interest for tourists, among them a number that hold special appeal for American Indian visitors and those interested in Native art and culture.

The U.S. Capitol Building, just east of the NMAI building, is a great place to start. Statues or busts of Sacagawea (Shoshone), Chief Washakie (Shoshone), and Charles Curtis (Kaw, U.S. Vice President under Herbert Hoover) are on display, as are a number of other Indian-themed paintings, murals, and statuary. Remember, however, that visitors must be part of a scheduled tour to enter the Capitol building. Arrange a visit with your senator or congressperson, phone 202-225-6827, or visit the Capitol's website at **www.aoc.gov** for more information about joining a scheduled tour.

The Smithsonian Institution offers a wealth of resources related to Native culture and artifacts. In particular, the National Museums of Natural History and American History, both located west of NMAI on the National Mall, regularly feature American Indian–related exhibitions. For more information about these museums and other Smithsonian exhibitions and programs, call 202-357-2700, visit the SI website at **www.si.edu**, or drop by the Smithsonian Information Center in the Castle Building.

The offices of most federal agencies and Indian organizations are not open to visiting tourists. The Department of the Interior (1849 C Street, N.W., 202-298-4743) is a notable exception, although you will need to schedule an appointment at least two weeks before your visit. Bedecked with murals by James Auchiah (Kiowa), Woody Crumbo (Potawatomi), Velino Herrera (Zia Pueblo), Allan Houser (Warm Springs Chiricahua Apache), Stephen Mopope (Kiowa), and Gerald Nailor (Navajo), the DOI building features a great many Indian motifs throughout. One gallery of Interior's museum is devoted to Indian culture and artifacts, and the wonderful Indian Craft Shop represents artists from 45 tribal areas across the U.S., with a range of goods that includes ceramics, weaving, jewelry, basketry, sculpture, and traditional Native Alaskan artwork. The shop, open without an appointment, also boasts an outdoor sculpture garden.

At Constitution Avenue and 19th Street, N.W., is the Tree of Peace, dedicated in 1988 by a coalition of Natives living in Washington. Representatives of the Haudenosaunee (Iroquois Confederacy) were special guests for the dedication. Members of an organization known as the Circle, which hosts a prayer vigil for the earth at the Tree of Peace each September, have planted four white pine trees nearby.

Washington is also a final resting place for a number of Native people. Several tribal delegates who died during visits to D.C. are buried at Congressional Cemetery (1801 E Street, S.E.; 202-543-0539; **www.congressionalcemetery.org**), and Indian veterans from the Spanish-American War, World Wars I and II, the Korean War, Vietnam, and the Gulf Wars are interred at the Arlington National Cemetery (Memorial Drive, Arlington, Virginia; 703-607-8000; **www.arlingtoncemetery.org**). Located at Arlington Cemetery next to the grave of Lt. Col. Carl Thorpe (Sac and Fox/Pawnee, d. 1986), the son of athlete Jim Thorpe, is the "Grandfather Plaque," a headstone-sized monument honoring Native American veterans. The plaque is the site of a pipe ceremony every Veterans' Day.

—Mitchell Bush (Onondaga), President Emeritus, American Indian Society

Photo Credits

All illustrations © 2004 NMAI, Smithsonian Institution, unless otherwise noted.

Wood Ronsaville Harlin, Inc.; inside flaps, p. 8–9, 20–21, 30–31, 42–43, 56–57

Chris Wood, p. 1, 34 (below)

Maxwell Mackenzie, © 2004; p. 2, 14, 19, 24 (both), 25, 26, 29 (all), 34 (above), 35

Courtesy of the British Museum, p. 10

John Harrington (Siletz), p. 11

Linda Martin (Navajo), p. 12, 37

Hayes P. Lavis, p. 22–23 (all)

Janine Jones, p. 36 (above)

Katherine Fogden (Mohawk), p. 36 (below)

R. A. Whiteside, p. 38 (below), 46 (below), 52, 55 (below)

Roberto Ysais, © 2002; p. 41

Photographs on p. 44-45 are stills from the Lelawi theater presentation, *Who We Are*.

Ernest Amoroso, p. 38 (above), 47 (all), 55 (above left), 60 (below), 62 (all)

Walter Larrimore, p. 46 (above), 51 (below), 53, 55 (above right), 61

Illustration from *How Raven Stole the Sun*, Felix Vigil (Jicarilla Apache/Jemez Pueblo), © 2001; p. 48

Reproduction authorized by Instituto Nacional de Antropologia e Historía, CONACULTA-INAH, Mexico; p. 50

Carmelo Guadagno, p. 51 (top)

Cynthia Frankenburg, p. 58–59 (all)

Amanda McClean, p. 60 (top)